FUND YOUR DREAMS

Like a Creative Genius™

T0058249

FUND YOUR DREAMS

Like a Creative Genius™

A GUIDE FOR ARTISTS, ENTREPRENEURS, INVENTORS, AND KINDRED SPIRITS

BRAINARD CAREY

ALLWORTH PRESS
NEW YORK

Allworth Press books may be purchased in bulk at special discounts for sales promotion, corporate gifts, fund-raising, or educational purposes. Special editions can also be created to specifications. For details, contact the Special Sales Department, Allworth Press, 307 West 36th Street, 11th Floor, New York, NY 10018 or info@skyhorsepublishing.com.

22 21 20 19 18 5 4 3 2 1

Published by Allworth Press, an imprint of Skyhorse Publishing, Inc., 307 West 36th Street, 11th Floor, New York, NY 10018. Allworth Press® is a registered trademark of Skyhorse Publishing, Inc.®, a Delaware corporation.

www.allworth.com

Cover design by Mary Ann Smith
Illustrations by Brainard, Delia, and Shiva Carey

Library of Congress Cataloging-in-Publication Data is available on file.

Paperback ISBN: 978-1-62153-648-2
eBook ISBN: 978-1-62153-650-5

Printed in the United States of America

This book is dedicated to Delia and Shiva.
♥

CONTENTS

INTRODUCTION

If you only use one good idea from this book, the cost of buying it will be repaid many times over.

Want more cash? Read this intro quickly—

This is a book for anyone who has an ounce of creativity in them—you could be an entrepreneur, an artist, a teacher, or anyone at all who is willing to go outside of traditional routes (a job) to gain income or a one-shot infusion of cash. You can use the money for a dream you have or a cause you want to support or an artistic or activist project you want to see realized. There are no limits or parameters on how the money is spent.

Sponsors, Patrons, Donors, Customers, and Angels are simply relationships, as well as parts of techniques you can use to have your event or visionary work sponsored by businesses and corporations to keep your dream alive and growing.

Sound dreamy? It's how almost every museum, filmmaker, and every individual dreamer raises millions a year, and it can easily work for you if you know the process.

So, if you want to know more in a short time, take this slim volume home and read it and then activate one of the possibilities I present. Read them all to see which one sounds like the most fun and easiest for you to do. Some of these ideas may seem impossible for you to do. Every idea will take effort for you to realize. Yet if you only use one good idea from this book, the cost of buying it will be repaid many times over.

How much are we talking about here? Anywhere from $500 to hundreds of thousands. In most cases, after raising money successfully once, you will find it easy to repeat the process, which is often a bit addictive because getting what you need and want is a turn-on for most people. An active person fundraising tends to raise more and more every year, because it gets easier once you understand the system.

Also, if you complete reading this short book, you can write and ask the author (me) questions, as well as send in your success stories. I plan to use the time you give me wisely so you can profit sooner rather than later with this book. Questions can be sent to brainardcarey@gmail.com.

An active person fundraising tends to raise more and more every year, because it gets easier once you understand the system.

"If you are distressed by anything external, the pain is not due to the thing itself, but to your estimate of it; and this you have the power to revoke at any moment."
—Marcus Aurelius, *Meditations*

Chapter 1

CREATE A PRODUCT

Money. It's what makes a business or most dreams flourish and is also what stands in the way of growth. In the early stages of *every* new venture, the very first concern and top priority is always where the money will come from. It used to be that in order to start a business the route was to visit the bank, provide reasonable collateral, and secure a loan. These days, with an economy that is often highly volatile and with the advent of the internet constantly changing the landscape of how things are done, the era of the bank loan is rapidly fading. Crowdfunding has taken the place of traditional overhead capital in many cases through sites like Kickstarter and Indiegogo. But what if you want to circumvent even these modern traditions and find a way to raise capital even more independently? What if you would prefer not to give a percentage of all income raised to one of the many online platforms like Indiegogo, Patreon, and Kickstarter?

The fact of the matter is, there are countless ways to secure yourself a little extra green on the side; the only obstacle is the limit of your imagination. Just ask Brian Chesky, CEO and founder of the now ubiquitous vacation and short-term rental platform Airbnb. In the early days of this business, Chesky and his cofounders Nathan Blecharczyk and Joe Gebbia had a problem. They were rapidly running out of money to run their nascent, unknown start-up.

The business itself was the result of chance. When a design conference flooded into San Francisco creating a space issue—there simply weren't enough hotel beds to fit every participant—the three cofounders used the lack of space to their advantage. Low on funds and needing to pay the rent, they opened their loft space to conference participants. Three air mattresses plus complimentary breakfast at $80 a pop not only helped three visitors find a place to stay, it got the rent paid and gave rise to what would become Airbnb.

There are countless ways to secure yourself a little extra green on the side; the only obstacle is the limit of your imagination.

Fast-forward to Denver, Colorado, in 2008. The Democratic National Convention was presenting the very same temporary housing need as the San Francisco design conference, and Airbnb was still in its very early stages. The team needed to solve a fundamental problem, which was figuring out how to fund their business enough to market it and bring in more paying customers.

They already knew that the DNC was a tremendous opportunity. The idea of people opening their homes to others was catching on. But things weren't growing quite fast enough; they needed another way to keep their little boat afloat.

That's when they came up with a most *un*conventional idea in order to capitalize on the convention in town. They would sell cereal.

You read that correctly.

They would sell cereal. The team ordered a thousand boxes from a local printer, got themselves a glue gun and some cereal, and went to work. They created a limited-edition series of politically themed cereals, namely Obama O's and Captain McCain. Each variety had five hundred boxes each, individually numbered and filled with real cereal. In the lead-up to the Democratic National Convention, the team sold off their cereal boxes for $40 each. It was thinking so far outside the . . . well . . . box, they had no idea whether their plan would pay off.

It took a bit of hustling to get the word out about their limited-edition breakfast series. The team turned to small-time bloggers asking them to run features to small audiences. This grassroots marketing began to snowball and eventually landed them on national network news, giving them and their cereal start-up funding an enormous boost.

Against all odds, the Airbnb founders sold every last box, raising $40,000 that would allow them to dig out of the serious debt running their little business had put them in. They took their capital and their unusual idea to Paul Graham, asking him for a spot in his start-up accelerator Y Combinator.

Graham was skeptical at first—this was 2008 and the markets had just crashed, setting off what would become the recession. He was looking for businesses that could survive during the austere times ahead. He was unconvinced that a rental company was one of those businesses.

Just when it looked like Airbnb would have to seek elsewhere, they revealed their unusual method of raising capital. Graham was so impressed by the success of the cereal boxes, he offered the team a spot. Their absolute ingenuity proved to the entrepreneur that they had what it takes to keep a business going even when success is slow and debt is piling up.

When it comes to funding your business, your art, or whatever your dream is, the sky's the limit as far as ideas go. If you are an artist, you have a serious advantage in that you are already used to thinking in ways that are completely different to the traditional ways the world goes round. Make this perspective work for you. Create and imagine ways you can earn money to keep your business or art practice afloat. Learn from the example of the Airbnb crew that sometimes, when the moment is right, the most outlandish ideas are the ones that will get you the furthest.

If you liked that idea, keep reading until you find the approach that seems the most exciting and most comfortable to you.

Against all odds, the Airbnb founders sold every last custom cereal box, raising $40,000 that would allow them to dig out of the serious debt running their little business had put them in.

CHAPTER 1 CHECKLIST

1. Write down the goal amount to be raised.

2. Come up with a product that is easily made and also attractive.

3. Give yourself a specific time frame to reach your financial goal.

4. Make your product (or have it fabricated).

5. Find a place that is heavily trafficked to sell your product.

6. Use social media to promote your product or event.

7. Reach out to bloggers for more coverage.

8. Write a press release about what you are doing.

9. Make a schedule on your calendar to manage your time on these tasks.

10. Follow up with any media inquiries; have a press kit ready.

11. Have a system to accept credit card payments so you can swipe cards (like Square or PayPal).

12. Meditate or visualize success (do not underestimate the power of this!).

"Nothing will teach you more about perceived value than taking something with literally no value and selling it in the auction format. It teaches you the beauty and power of presentation, and how you can make magic out of nothing."
—Sophia Amoruso

Chapter 2

AUCTIONS FOR EVERYONE

My auction guru, Jim Wintner, the CEO of benefitevents.com, which is a personalized auction platform, likes to tell a story about Warren Buffett and his late wife Susan. Susan's idea was to auction off lunch with him. They began to do that and were netting as much as $20,000 for lunch locally. The money went to Glide, a San Francisco charity that provides food, health care, and other services to the homeless, the impoverished, and people struggling with substance abuse.

Then they began using eBay and sold the lunch for $350,000! Every year since then Buffett has done this, and the most he has raised from one lunch with Warren Buffett is $3,456,789 in 2016. That's right, over *three million dollars*—through eBay. The lesson there is to figure out who is the Warren Buffett in your community to get big success for your auction, and don't hesitate to go for big money. It's okay to think about hundreds of thousands of dollars, or millions; both require the same process, and will help you realize your big dream.

Auctions are one of the best techniques in the strategies of many nonprofit organizations. Silent auctions make appearances at gala dinners and preschool fundraisers alike. They draw on the basic human tendency to consume and compete, sometimes with surprisingly good results.

STRATEGY

Auctions are one of the best techniques in the strategies of many nonprofit organizations. Silent auctions make appearances at gala dinners and preschool fundraisers alike. They draw on the basic human tendency to consume and compete, sometimes with surprisingly good results. So why not try your hand at an art auction? Not only is it a great way to raise a little money, but if you know a few artists, you'll also help them get their art out into the world. This process will work for entrepreneurs of any kind as well as nonprofits and individuals who have a cause. You can auction off all kinds of things, not just art, but consider auctioning art that is from local artists. You can of course auction other objects, like the clothes or ephemera of well-known people, lunch with a local hero, or antiques and other collectibles. There are many themes you could have for this. Let's start with an auction just for art, but keep in mind these techniques could be mixed with all of the above objects and collectibles.

There are a few ways to approach an art auction. You can choose to do the entire thing online via your own social media channels or a third-party site or you can plan a live event. Ideally, combine the two for maximum impact. You can use the power of the internet to build momentum before bringing your auction to a non-virtual space or a virtual one or both.

Consider whether you want to make this a collaborative event. If so, ask around within your circle to see who else might be interested in donating art for the occasion. You can also post an announcement and an open call for art on a website like Craigslist or something more local. Agree ahead of time how proceeds will be divided and put all of that in writing. I think that the artist should always get half of what is raised; I feel an auction takes advantage of an artist if the auction organizer asks for a 100 percent donation. So for artist-donated works, the auction (you) gets 50 percent and the artist gets 50 percent of the total sale price.

You don't need to host a gala event to hold an auction. Art auctions and even exhibits can take place in someone's kitchen. Hans Ulrich Obrist, the renowned art curator, held an exhibition in his kitchen early in his career simply titled *The Kitchen Show*. Be creative and resourceful when it comes to finding the right place for your auction. Really, all you need is some wall space and room to mingle.

Decide whether you wish to set a minimum price for each piece or simply let things take their own course. Setting a price, known as a reserve price, ensures that if pieces sell you make at least a minimally acceptable profit, but there is also inherent risk that auction attendees might be unwilling to pay up. Keep reserve prices modest if possible.

It is important to get the word out about your upcoming art auction event. Hit your social media channels, local newspapers, online community calendars, and more. Create bright, colorful flyers to hang in places where there might be interest in an event such as this. Write up a press release. Do what it takes to get the buzz going! Tell your friends!

You can of course auction other objects, like the clothes or ephemera of well-known people, lunch with a local hero, or antiques and other collectibles. There are many themes you could have for this.

Consider making a little investment in your event. By simply offering light food and drink (which you can advertise on your promotional materials) you will likely draw in more people than you would without. Make it a party; no one can resist some free food and a good time.

Another incentive to get people in the door is a raffle. You can easily purchase a roll of tickets that everyone can take as they arrive. Check office supply stores for rolls of tickets. Conjure up a prize and, late in the event, draw a ticket. Prizes could be anything from a free piece of art to a studio visit and picnic lunch or dinner with you, a digital download of a book, or a collectible or antique. Use your strengths to make the door prize exciting and unique.

Decide whether you wish to have only a silent auction or if you prefer to include a live component as well. For a silent auction, you will need bidding sheets for every piece of art available. If there is a reserve price, indicate this in the top slot of the bidding sheet. The basic format for a bidding sheet is a two-columned table. One side is for prices, the other side for names and contact information.

HOLIDAYS AND TIMING

Timing of your auction can certainly be an important factor as well. Around the holiday season might be an ideal time for an event like this advertised as a holiday shopping opportunity. Other times of year, like during the height of summer, could be tricky as many people are traveling.

Hosting your own art auction can be a fun way to raise a little money, to meet some artists and collectors, and to network. Your best weapon in an event like this is careful organization. Don't overcomplicate things, know your plan, and advertise well. If the first auction goes well, wait a few months and give it another go. There is no limit to the possibilities or how much you could raise in one auction.

CHAPTER 2 CHECKLIST

1. Find an auction guru (like Jim Wintner at benefitevents.com), or a platform you are comfortable with.

2. Find a space to hold the auction if you are not doing it online (though you can do both at once).

3. Find a local hero to auction off a lunch with.

4. Write a press release.

5. Be ready to swipe credit cards.

6. Assemble auctionable items: Art (pay artists at least 50 percent of take), gift certificates, rental cars, dinner at a restaurant, etc.

7. Get an auctioneer who can talk and project their voice.

8. Have a pre-auction reception so buyers can see what will be available.

9. Make a list of VIPs that you will personally invite by phone.

10. Make a firm start and end time to the auction (live or online).

11. Call reporters about your press release—use the phone!

12. Have a team of at least three people to help you with the live auction.

"When you go out and meet new people, you can come up with new ideas and be enlightened and help the country become a better place."
—Marc Veasey, Texas Congressman

A MOVEABLE FEAST: FUNDRAISING OVER DINNER

Raising funds is easily one of the central themes in any visionary's life, but it is also a theme in almost everyone else's life! The following example was used by some artists to great effect, but anyone could start this and raise money for individuals for any cause, even a new business venture. The most exciting aspects of this plan are the friends you will make and the fun you will have in the community that is built through the process.

Since 2009, FEAST (Funding Emerging Art with Sustainable Tactics) Brooklyn has produced thirteen dinners, funded thirty-two projects, and awarded $21,406. Meanwhile, similar models have emerged all over the country, resulting in a network of organizations committed to rethinking how ideas are financed and communally experienced. Their model is what is detailed in this chapter, started by a few artists and visionaries with no budget and ending up with thousands of dollars, and many memorable dinners where lasting friendships were made.

Everything costs money, and as a visionary with an idea for a business or project of some kind, it may sometimes feel difficult to keep up. There are only so many grants to go around, and maybe your Kickstarter isn't off the ground quite yet. When it comes to raising capital, some people are turning to creative, nontraditional fundraising concepts in order to help each other move forward in the field they share in common. One way people are doing this is through FEASTs. This relatively new and exciting concept is beginning to take hold. Not only does it offer a way to raise a little money, it brings communities of creative people together to work collaboratively.

Get ready to host—you're throwing a dinner party. But this is no ordinary dinner party, this is a FEAST. And while you might think that your own dining room is the right spot for this event, it's a good idea to think a bit bigger. But on a budget. Securing a venue will be your biggest challenge, but it can be done. Churches often offer free space for community events, and what's more, they often have a kitchen. Start calling around until you find a venue that will allow you to take over for an evening.

Once your venue is secured, pull together four or five artists or entrepreneurs with ideas they haven't launched yet. These will be your collaborators for the event. Plan your menu and have each presenter prepare a short talk (five minutes) about their work. If possible have your presenters bring large cue cards with them to the FEAST—to help the audience understand what they are doing. It's important that all participating presenters be briefed up front about the nature of the FEAST. As you read on you will understand that for each event, only one presenter will receive monetary support. But a FEAST is not meant to be a single serving, it is designed to present more opportunities down the road.

Get the word out about your event. Use whatever means you have available. Social media is a powerful tool—your personal or professional Facebook pages are both perfect places to advertise the FEAST. Tweet it, make posters, do whatever it takes to drum up interest. Let your potential guests know that there will be a minimum donation of $10 to cover food costs and that the evening will feature a collection of presenters all ready to present their vision.

The most exciting aspects of this plan
(a FEAST) are the friends you will make
and the fun you will have in the community
that is built through the process.

The night of your FEAST, once your guests are settled in with their meals, the competition begins. That's right, this is a dinner party like no other. Each presenter (four in total) presents their work (with five minutes each) to the crowd, who have been provided with ballots to cast for their favorite presenter. When all presenters have stated their case, ask your guests to cast a ballot for their favorite presentation of the evening. When dinner is done, and before dessert is served (because what's a dinner party without dessert?!), announce the winner.

The presenter who wins the FEAST takes half the spoils. That means out of every dollar collected at the door, half goes to the winning presenter, who also gets the opportunity to exhibit their project at the next FEAST. The other half goes to you and your project for putting this all together.

The second FEAST operates just like the first. Collect your presenters, then prepare your statements to the crowd, wine them, dine them, wow them with visionary splendor. All the while, the walls of your venue are adorned with the previous winner's projects, and no matter which presenter wins, you will also raise money for your own project.

FEAST is a true community event. While only one presenter each time will walk away with the prize money, there's always next time, and the money raised could be changed to a different percentage of the door, etc. Not only that, you'll form networks and bonds with fellow presenters as well as members of the community. All of this is absolutely crucial when building a business and network as an entrepreneur, artist, or visionary of any kind.

Prepare meals that reflect the ideas being discussed or the mood you want to generate. Serve food arranged as still lifes or pick a theme color for the evening and serve only foods that match.

Get creative with your FEAST. Prepare meals that reflect the ideas being discussed or the mood you want to generate. Serve food arranged as still lifes or pick a theme color for the evening and serve only foods that match. Just be sure your food tastes as good as it looks. Pair your food with inviting music (when there isn't a presentation to hear) and create interesting mock-tails to complement your menu. There are no limits to the fun you can have planning your FEAST. And the more memorable it is, the more likely you will see repeat guests and positive word-of-mouth for next time.

The frequency of your FEAST is up to you, but it's probably best to leave a little time in between in order to combat market saturation. Consider hosting one every few months, maybe quarterly. Ask past guests to spread the word through their own social media channels. The more of these you do, the more you will raise for yourself as well the lucky winner of the evening.

CHAPTER 3 CHECKLIST

1. Find a venue for your FEAST—it could be a church basement, a home, a gallery, a loft, or a warehouse space.

2. Write a press release explaining it all—with enthusiasm.

3. Approach restaurants with the idea; ask for food donations

4. Assemble a team of four friends (including you) to help.

5. Plan your menu (keep it simple, like soup and salad perhaps).

6. Make posters.

7. Use social media for local buzz—Facebook, Twitter, etc.—tell everyone to come!

8. Pick your presenters: four or five visionaries/entrepreneurs/artists.

9. Choose one team member to handle the money and disburse payment.

10. Choose one team member to do the accounting.

11. Decorate the venue—balloons, banners, etc.—make it fun.

12. Practice your announcement to diners, explaining the process of voting.

"The poem is a form of texting . . . it's the original text. It's a perfecting of a feeling in language—it's a way of saying more with less, just as texting is."
—Carol Ann Duffy

Chapter 4

TEXTING YOUR WAY TO FULL COFFERS

There are lots of benefits to text to give. Mainly, it is incredibly easy to use once it is set up and it also allows for spontaneous giving.

On December 3, 1992, engineer Neil Papworth sent the message "Merry Christmas" from a computer to the mobile phone of his colleague Richard Jarvis. It was one small message for man, one giant leap for phone-kind. This very first text message would go on to launch a cultural shift so seismic it has not only changed the way we communicate, it has also given rise to a whole new language of text speak. So what does texting have to do with fundraising or art?

The text message has come a long way from those humble beginnings. These days texts are used for all sorts of things from petition signing to mass calls to action—and yes, as you probably know, even fundraising. Text to give (also known as *text to fund* or *text to tithe*) is a method of fundraising that allows donors to give directly from their phones. There are lots of benefits to text to give. Mainly, it is incredibly easy to use once it is set up and it also allows for spontaneous giving. That is, the moment a backer decides to donate, the means to do so are literally at his or her fingertips.

Text to give is typically used by organizations, often in the wake of a major event like a natural disaster, in order to mobilize funds quickly. Text to give is well suited to this sort of scenario in that it requires a rather broad public awareness to succeed. Additionally, unlike some of the other fundraising ideas I have discussed in this book, text to give is better suited to organizations and not individuals. Consider forming a group of entrepreneurs or inventors, which could meet at local collaborative workspaces or a chambers of commerce. This could be an ideal platform for a text to give campaign.

A recent successful use of the form was implemented by James Eberhard. One morning he was awakened by a phone call from the US State Department. A huge earthquake had hit Haiti and the government wanted Eberhard to put together a donation program as fast as possible.

Two hours later, his mobile software company, mGive, launched a national campaign that let people donate $10 to a number of charities via cell phone. All contributors had to do was text the word HAITI to the number 90999; the pledge would show up on their cell phone bill. Four months later, the campaign had raised more than $40 million.

There doesn't have to be a disaster to raise money, even millions, for your idea, but a dramatic story can help. Before you begin, you'll want to research some of the available providers because text to give requires a third party to facilitate donations. When choosing a provider, ask around at other nonprofit organizations who may have run similar campaigns and see who worked for them.

There are a few things to know when going into a text to give campaign. One of the most important is the use of the shortcode. A shortcode is the number donations will be texted to. Something usually around five digits long. Do not be fooled into thinking that you need to purchase your own unique shortcode. Far from it. Shortcodes are expensive—they range in the thousands of dollars. Instead, by all means, be willing to share a shortcode or simply obtain your own unique phone number just for the organization and fundraise through that. It will cost you *far* less and you'll be able to come away with more donations earned and less sunk into getting your campaign up and running.

Because text to give campaigns are reactive by nature, it's a good idea to publicize your efforts as widely as possible. Begin an advertising campaign well in advance of your actual fundraising. Take to social media and even local print options in order to get the word out about your intentions. Be sure to include all the instructions so that donors can text. Try launching a separate page on Facebook just for your fundraising campaign. Create a countdown to get people excited. Make it memorable. Maybe for each countdown day, offer a new and exciting post, whether it's a short and funny performance or a new prize that is given away, or something related to the campaign that is memorable. Whatever you do, make sure it's engaging. You want people marking their calendars for the start of this thing.

**There doesn't have to be a disaster
to raise money, even millions, for your idea,
but a dramatic story can help.**

The initial setup for a text to fundraise campaign does involve some work. You'll need to dedicate time to getting things running smoothly so that when your campaign launches all your donors have to do is text and give. There are lots of options out there when it comes to which third party to use for your campaign, but here are a couple of trusted names in the world of nonprofit text to fundraising.

MobileCause is great for nonprofits of all sizes, from large multinational organizations to a very small collective. MobileCause offers more than just a campaign service; they also allow organizations to send invitations and reminders to potential backers.

@Pay is another strong platform that is not only great for nonprofits of all sorts, it also doesn't place a cap on donation amounts, so your backers can decide for themselves how much to give.

There are countless others out there, all offering their own unique benefits. Do your research, ask around, and find the provider that is just right for your campaign.

As with any fundraising campaign, the bottom line is that you get out of it what you put in. The more work you're willing to do up front, the more return you'll see in the end. Get the word out, make it exciting, and the sky's the limit.

CHAPTER 4 CHECKLIST

1. For your text campaign, choose the organization to benefit.

2. Build your story—real drama helps!

3. Spread the word on social media.

4. Consider social media ads, like Facebook and Twitter.

5. Research and choose the provider you will use.

6. Write a press release to local news, radio, and television. In all press information be sure to include explicit instructions on how to donate.

7. Call local news—that can make the difference between a story or no story.

8. Create a Facebook page just for the campaign.

9. Your shortcode—find one to share ideally instead of buying your own.

10. Find a campaign manager software to use (suggestions in the chapter).

11. Come up with a new or creative way to get the word out as well as the traditional routes—consider a video, giveaways, and public talks at libraries.

"Fundraising is the gentle art of teaching the joy of giving."
—Hank Rosso, author of *Achieving Excellence in Fund Raising*

Chapter 5

FUNDRAISE BY DESIGN

Every writer has heard the old adage, "write what you know." While this does not mean that you cannot step outside your own reality to construct beautifully fanciful stories (after all, J. R. R. Tolkien surely never encountered a Hobbit or an Orc) it does mean that writing about a topic already familiar to you gives you an automatic leg up. So too, when you are a creative person in need of fundraising ideas, turning to something you already know well as your stepping-stone is a good place to start. Using your creative flair to generate funds is a great way to tap into your strengths in order to support your business needs.

Any parent or grandparent (or aunt, uncle, etc.) will tell you that there is no shortage of ways to turn children's art into beautiful products. The same is true for anyone wishing to raise funds through visual objects and art. These days there are any number of websites designed just to help you turn your designs into beautiful merchandise to be sold. Three such websites stand out among the rest, so I've gathered them here to talk about the ins and outs of each. If you feel you are not creative enough to make designs, you can hire a local designer to help you.

Bonfire is probably one of the strongest contenders when searching for a home for your wearable art campaign. This is what they do and they do it well. Whether it's a fundraiser for a family in need or venture capital for a new project, Bonfire has the tools and the products to stand out from the crowd. Bonfire is an easy-to-use platform that does much of the background work for you. Begin by selecting from their collection of curated apparel. Bonfire maintains a limited stock of items that sell well. You choose which ones you want to work for you and start designing. Bonfire makes it easy to upload your own designs to customize their products. From there, you set your own prices and create your campaign and customize your campaign website. Bonfire campaigns run for a limited number of preset dates. Once a campaign is complete, all shirts ordered will be created and shipped. There are no fees and you are not required to keep inventory on Bonfire. The cost of services comes out of your final sale prices. You can run unlimited campaigns through Bonfire. It's a great service that has received rave reviews from publications like *Rolling Stone* and *Huffington Post*.

When you are a creative person in need of fundraising ideas, turning to something you already know well as your stepping-stone is a good place to start.

Custom Ink, formerly known as Booster, is a site similar to Bonfire. Here, you can design your own products and sell them as a fundraising tool. Unlike Bonfire, which specializes in apparel, Custom Ink has other merchandise options. You can create bags, hats, and other non-T-shirt items. Similar to Bonfire, Custom Ink allows you to take orders directly from the site, saving you the hassle of keeping your own inventory and winding up with a whole bunch of stuff nobody buys. The design team at Custom Ink is available to help optimize your design, or you can choose to go it alone. Custom Ink is known for their excellent customer service and has been a staple in the fundraising community since 2000. What began as a small business between a couple of college friends has blossomed into a powerful fundraising tool.

CafePress is a bit different from Bonfire and Custom Ink in that it is not technically designed to be a fundraising platform. Rather, CafePress is a place where you can design products with your own images and sell them through the online market. There is no time limit and CafePress will do the marketing for you. While this may sound pretty ideal, bear in mind that CafePress is all but saturated with products, so standing out from the crowd may prove tricky. On the upside, though, there are lots of products to choose from, not just apparel, and many creative people turn to CafePress as a way to market a design and turn it into attractive merchandise. The process couldn't be simpler, and CafePress will even suggest items that best fit your particular design.

These are only a few of the sites designed to assist you in launching your own merchandise campaign. As a creative person, your work ideas may inherently lend itself to this sort of thing. Not only is this a great way to raise some capital to keep things afloat, it is also a way to get your work out into the world. Putting your designs (or ones you use from someone else) on wearable items means that wherever those items go, there is the potential for conversation about your ideas. We've all approached someone wearing an interesting shirt to give a compliment and ask questions. Why shouldn't the next conversation piece be something you create that helps you sustain your independent projects in the meantime?

If you feel you are not creative enough to make designs, you can hire a local designer to help you.

CHAPTER 5 CHECKLIST

1. Develop your budget.

2. Write down your story and pitch.

3. Make a product, or a series of products, or ask a designer to make one or several for your campaign.

4. Play to your strengths—stick to what you know.

5. Choose a site (suggestions in the chapter) for your sales portal.

6. Write a press release and send it out.

7. Reach out to bloggers, ask if they will feature your product.

8. Make a dedicated webpage for your product(s).

9. Make a dedicated Facebook page for your product.

10. Take great images of your product for the web.

11. Follow up with press by calling on the phone.

12. Consider talks at the local library and other venues about your campaign and cause.

"It is more rewarding to watch money change the world than to watch it accumulate."
—Gloria Steinem

Chapter 6

START A FESTIVAL

If you are an artist, getting your art into a gallery can feel like an intimidating and overwhelming process. Art fairs and festivals are other options, but competition can be stiff and it may feel like it's all about who you know. In Glasgow, Scotland, a small group of people have come up with a creative way to display art without the need for galleries, fairs, and festivals, and to promote community engagement at the same time. The funds in this case come from buyers of art, or patrons. And this method could be used even if you are not an artist—it is simply a way to draw a crowd and have a good time based on a series of ideas.

It's called the Glasgow Open House Arts Festival, and its genius is matched only by its simplicity. Here's how it works. On a biennial basis, Glasgow Open House presents a multifaceted arts festival throughout the neighborhoods of the city. Rather than setting up in public spaces, galleries, and theaters, the festival relies on residents willing to open their homes as temporary art and performance spaces. Absolutely anyone can apply to exhibit or host. The festival brings emerging and established artists, performers, and collectives to the public, often providing a platform for those working outside the bounds of the mainstream art world.

Participating houses aren't relegated to one part of the city; rather, people anywhere who have a space that can handle a dozen or more people walking through can be involved. The organization behind the festival facilitates various walking tours that bring together clusters of participating homes.

Establishing your own open house arts festival may not be as difficult as you think. The best way to start is with the people and homes in your immediate social circle. Maybe you have a cavernous living room or a bedroom with particularly interesting light. Really any space can be used with the right sort of preparation. You don't have to span the entire city during your first year. Start small and do quality work to make your first effort memorable.

Establishing your own open house arts festival may not be as difficult as you think. The best way to start is with the people and homes in your immediate social circle.

Once you have decided on your space or spaces, the next step is to prepare them. While this is a home, for the event it is also a public venue. That means you may want to do a little bit of alteration in order to get your spaces ready to host some crowds. Moving or removing furniture entirely helps with the flow of foot traffic so that no one finds themselves stuck in a corner between the sofa and a wall of other viewers. If the room is large enough, leave furniture in the center (museum style) so that visitors can take a seat and view the work. Breakables and valuables are best kept out of harm's way, of course.

Promoting your event can be as simple or far-reaching as you choose. For the first year, you may want to keep things a little low-key, advertising only through social media and friends. Or you may want to try your hand at a little further outreach right off the bat, leaving flyers at bookstores and cafés in the areas where you know there will be patrons interested in such an event.

Consider hosting an opening reception. Nothing fancy, but an event to mark the beginning of your festival just like every gallery does for a new opening. Provide refreshments, and have the artists on hand to discuss the work. For an event like this, it is best to keep things casual, not schedule any sort of talks or demonstrations. An open house format allows people to come and go as they please and purchase the art if they are interested.

Schedule your event for a time of year when it is generally pleasant to wander outdoors. This saves your potential audience from having to battle harsh conditions and also saves your interiors from being a mess of snow or mud tracked in on every single shoe through the door. Little practical considerations like this can go a very long way toward making your event that much more pleasant.

When inviting the public into private spaces, it is important to draw clear boundaries. Managing traffic flow can mean the difference between a smooth event and one that finds strangers in all sorts of unexpected locations.

At every open house venue during your festival, make sure there is someone from the organizational group on hand to field questions and deal with any potential issues—not to mention to keep visitors out of areas of the house where they aren't welcome.

Which brings us to another important point. When inviting the public into private spaces, it is important to draw clear boundaries. Managing traffic flow can mean the difference between a smooth event and one that finds strangers in all sorts of unexpected locations. Keep doors closed (and locked if possible) and make use of baby gates where you want to keep foot traffic out. By doing this you not only protect the spaces, you help streamline the process, which is better for all.

Glasgow Open House Arts Festival is a thriving event. While yours may start small (just like theirs did), with some careful planning and a lot of outreach, you could find yourself with a solid biennial—or even annual—event that brings art to your community, brings your community together, and often generates significant sales of artwork.

If you are the organizer of an event like this you could modify it so that all sales are done online through your website, and for that, you can take a percentage (perhaps as much as 30 percent) of all sales, which will help with costs of the festival and will also put money in your pocket for your own dreams to be realized.

CHAPTER 6 CHECKLIST

1. Name your festival (check the chapter for case study name).

2. Find at least three collaborators.

3. Set a definite start and end date.

4. Pick a geographical area (set boundaries).

5. Find multiple venues within the area (homes or offices).

6. Make a dedicated website for the festival.

7. Assign one person to manage publicity.

8. Make a dedicated Facebook page.

9. Write a press release; send it to TV, radio, and local newspapers and magazines.

10. Write to bloggers; get them involved with the event as it progresses.

11. Make big posters and postcards.

12. Make signage clear at venues.

"How wonderful it is to be able to write someone a letter! To feel like conveying your thoughts to a person, to sit at your desk and pick up a pen, to put your thoughts into words like this is truly marvelous."
—Haruki Murakami, *Norwegian Wood*

WRITE LETTERS THE OLD WAY

Dear Readers,

There was a time when letters traversed the globe the way that emails do today. Letters were the only way to communicate with friends and family far away. They were the means by which people expressed themselves, pouring the contents of their minds and hearts onto bits of paper to be sealed and sent out to the minds and hearts of others. There is a different quality to letters than email or other forms of digital communication. Letters possess an inherent authenticity that is more difficult to achieve electronically. My own story of learning this art to raise money is also in this chapter, because it is the means that I use most often.

As an entrepreneur, artist, or visionary who relies on independent funding to continue in your chosen career, patrons and sponsors play a potentially large role in keeping you afloat. But how do you communicate with potential patrons and sponsors to make them aware of your existence, your work, and your need?

Whether you write it by hand or type it out onto beautiful paper, a letter is a great way to be noticed by a potential patron or sponsor. In these times we are all too used to receiving emails all the time for just about any reason imaginable. What we don't receive are letters. This beautiful method of communication has been lost in the shuffle of our fast-paced digital lives.

Asking a patron or sponsor for money is an intimidating task, to be sure. Writing a beautiful letter can be a way for you to make an introduction *and* an impression, taking some of the worry out of that first contact.

There is a simple process to this that can be easily used for any scenario. If you are about to design a line of clothing, look at a place like a fashion museum. Their donors are listed on their catalogs and website in most cases. If you are a product designer, or building a brick-and-mortar business, join a local chamber of commerce to connect with other CEOs who could partner with you or sponsor your idea. If you are a visual artist, contact information for potential patrons and sponsors can sometimes be found on museum websites if you know where to look. Search out lists of trustees and board members; these are the museum backers who are sometimes willing to respond to individual artists. Gather some names, do your research, find the address of their foundation (most have one), and start writing.

Celebrities can sometimes be called upon to lend their support to an interesting cause. Again, writing a beautiful letter is a wonderful way to make an introduction.

There is a different quality to letters than email or other forms of digital communication. Letters possess an inherent authenticity that is more difficult to achieve electronically.

In this day and age hardly anyone is used to receiving letters. When they do, it makes an impression. Writing a personal, honest, heartfelt note that expresses your intentions and your desire for a small bit of support can really work.

What about the particulars of actually writing the letter? Must it be handwritten? If you have nice, legible handwriting, this is strongly recommended. If you don't, consider using a typewriter if you can get your hands on one. Classic type from an old typewriter creates a lovely, nostalgic aesthetic. If neither of these is available to you, write your letter out in a computer word processing program and print it. Choose a nice font and include some personal touches on the finished piece. If you're a visual artist, by all means, mark up that page.

Other touches to consider are a wax seal for the outside of your letter. You can create and purchase your own wax seals at various websites. This small touch gives so much to your letter. Choose your paper carefully. Rich, handmade paper will make a gorgeous impression. If this is unavailable, find a heavy, quality paper for your letter. Whether you're writing by hand or printing, paper should be carefully considered.

The contents of your letter should be heartfelt. Be honest about who you are and your needs. Write as eloquently as you can, using formal greetings, and never, under any circumstances, resorting to any sort of text speak or modern abbreviations. Proofread your letter more than once, walk away from it, and come back to reread, checking for any confusing or poorly written passages. It's best to write a draft on plain paper before turning to your final product.

In this day and age hardly anyone is used to receiving letters. When they do, it makes an impression. Writing a personal, honest, heartfelt note that expresses your intentions and your desire for a small bit of support can really work.

Be sure to include all of your contact information in the letter, even your email. Just because you've written this letter doesn't mean that the recipient will want to pen one back in the same fashion. Be sure to let them know how to reach you in the twenty-first century.

Letters are an all but extinct art form. Let their beauty and rarity work for you. Write with confidence, know your audience, and speak from the heart. Just the act of doing this is an art that is satisfying, but the responses you get will be the icing on the cake, so to speak. Try it at least once, but the more you write the more you will receive.

My story is that I wanted to raise money for an art project and I didn't know where to start. Since it was art, I looked at names of donors to local museums. For me, that meant the Whitney Museum of American Art. I looked at the board of trustees on their website and began trying to contact them. I wasn't sure exactly what to do or say in the letter, so I started by trying to meet one of these people. I wrote down about six names and decided I would try to meet them at an opening of the museum.

I went to a major opening and began scanning the crowd for some of the faces of those six people and I saw one I recognized. I went up to her and asked her how she liked the show and introduced myself. We chatted a bit about the show and then I asked her if I could tell her about a project I was trying to get funded. She responded with what looked like a reluctant "Yes," and I said I was trying to raise funds. She stopped me and said I could call her sometime to discuss that and moved on to another conversation, but gave me her card.

I called her early one morning and I explained that I didn't know how to write a proper letter asking for financial backing. Then she explained how when she gets beautiful letters in the mail, she often keeps the letters, and finds that to be very important. She said this before even discussing the content. She simply liked a truly beautiful letter. She also told me that you should do your research and not ask someone for too much or too little, to find out what the person you are asking has given in the past, to get a sense of them and what they do, which she said is fairly easy by researching online. At the end of the call she said to send her a letter when I was ready.

I sent her a letter on handmade paper in a handmade envelope, both of which I bought at a store that sold beautiful paper. I handwrote the letter and used sealing wax to close it and then put it all in a FedEx envelope. She sent me $1,500, which was a great thrill for me. I used the same method over and over again. I wrote to famous artists, to other trustees, and most sent at least $500. That began my lifelong interest in crafting letters that are beautiful and that raise money. You can learn more from me with a course I teach on how to craft letters at patronsandsponsors.com. My class has raised over $100,000 to date by just writing letters.

CHAPTER 7 CHECKLIST

1. Read letters written by poets and writers for inspiration.

2. Buy beautiful (handmade) envelopes and paper.

3. Use a fountain pen or a very good ballpoint pen.

4. Buy sealing wax and use a coin (an old one) for the seal.

5. Perhaps lightly perfume the letter (optional).

6. If you can't handwrite it, use an elegant font, but not too ornate.

7. Make it at least two pages long.

8. Write with grace, as though you have all the time in the world; be influenced by the poets of yesterday.

9. Make a doodle in the margins or the body of the letter for levity.

10. Be sure to have an easy-to-type-in domain and also an address to send a check.

11. Enclose a small gift (optional) like a handmade bookmark.

12. Put the finished wax-sealed envelope in a larger envelope and use beautiful stamps.

"You never change things by fighting the existing reality. To change something, build a new model that makes the existing model obsolete."
—R. Buckminster Fuller

P2P CAMPAIGNS: VIRAL GOLD

If you decide to launch your own P2P campaign, strive for authenticity. Don't try to guess what might catch on and go viral; instead just speak your own truth. Tell your story, why you're fundraising, what you have to bring to the world. By doing this you're way more likely to get willing participants to chip in a little to your cause and spread the word.

You probably see Peer to Peer (P2P) fundraising all the time and don't know it. It is present on every social media platform, during times of crisis, national or international disaster, at the holidays, or during school fundraising drives. We walk, run, and shop P2P. Likely you have participated at least once, been moved to the point where you feel you have to act. For some, it may be the plight of stray animals that leads them to action, for others it could be eradicating childhood illness. Whatever the cause, P2P fundraising takes advantage of a wide network in order to get the job done, and it's been a roaring success.

One of the best-known P2P campaigns has to be Relay for Life. This enormous event began in 1985 when Dr. Gordon Klatt spent twenty-four hours circling a track without stopping to raise money and awareness for cancer. Over the years, the event has grown and grown and grown, and these days it can be found in just about every community. The premise is pretty simple: participants gather teams to spend a single night not resting while they work the track and raise money from personal donors.

Relay for Life strikes at the very heart of P2P. It takes a smaller network and broadens its scope in order to maximize fundraising potential. There are countless others that follow this model using walkathons, road races, and lots of other ideas . . . remember the Ice Bucket Challenge for ALS? That was a great example of a P2P fundraiser that went viral.

If you decide to launch your own P2P campaign, strive for authenticity. Don't try to guess what might catch on and go viral; instead just speak your own truth. Tell your story, why you're fundraising, what you have to bring to the world. By doing this you're way more likely to get willing participants to chip in a little to your cause and spread the word.

Getting the word out is the whole idea. So while you want to encourage those who see your fundraising campaign to join the effort, you also want to encourage them to share it with their own networks. Keep things upbeat and interesting and you're far more likely to garner the social "shares" you need to run a successful P2P campaign.

P2P doesn't simply mean creating a website, adding a share button, and sitting back to watch the donations pour in. As with anything that succeeds, there is great effort involved. And also as with most things, the more thought you put in, the better the results will be.

Consider ways you can make your own P2P event capture the attention of those who have never met you in person. After all, you are asking your network to share the needs of a complete stranger with their friends and family—better make it interesting!

Take a page from the Ice Bucket Challenge. Dare potential donors to perform online to engage them in the process.

An actual event is a great way to make your P2P stand out. It doesn't have to be on the scale of Relay for Life, and it doesn't even have to be in the real world. A virtual event can be just as effective.

Play to your strengths. If you're not athletic, don't decide you'll run twenty miles in order to fundraise. If you're a scientist, you already have an interesting skill set that you can use to your advantage. In the scientist example, you could organize a P2P around an all-day science fair or interactive demonstrations. There are a few ways to do this. You can invite people to an open-house-style event, setting up a donation page prior to the date of the open house so that all those who wish to visit and see the science demos must first become a backer. Pick a date and plan a marathon of fun and interactive experiments for the day. Participants come in, watch you do your thing, have some fun, and get a backstage tour of how it all comes together.

This same process could be done with product launches or art. In the case of art, if you don't have the space to invite the masses, why not a virtual open studio? Again, pick a date and on that day live-stream it up. Invite potential donors to watch as you embark on a relay of art, a ceaseless studio session to create a buzz and garner exposure for your work.

If you would rather get others involved, organize a participatory event. It doesn't have to be complicated. If you have the means to create a road race, then of course, go for it, but there are lots of things to consider, and cost can end up being a huge factor for an event like that. Instead, take a page from the Ice Bucket Challenge. Dare potential donors to perform online to engage them in the process. You could challenge them to create their own work of art, or something beyond silly. Just make sure it's safe.

How you plan your own P2P is limited only by your imagination. In these days of vast, virtual networks, there is no reason not to leverage the connections you already have to reach others. The more people you reach, the more likely you are to find the ones excited about your work and ready to get involved in the effort.

CHAPTER 8 CHECKLIST

1. Tell your story and make it concise and powerful. It is about changing the world.

2. Set up an open house/apartment event to introduce your campaign.

3. Organize a participatory event (something athletic or even an art paint-a-thon or open mic).

4. Your network in P2P is broad, so plan your campaign and outreach with a demographic you are trying to reach.

5. Plan who will make up your team, and invite them to a onetime event.

6. Make a goal amount of what you want to raise.

7. Send out a press release.

8. Call at least ten people that you sent press releases to.

9. Shout about it daily on Facebook, Twitter, and LinkedIn.

10. Look at the Ice Bucket Challenge (one of the most successful campaigns ever of this type) and make your own challenge.

11. Sit in silence for ten minutes a day and imagine the campaign success and see the elements working (if you don't do this, the default thinking is the opposite).

12. Set a length to the campaign, and make daily announcements of the amount raised so far.

"The best early-stage venture capital investments appear obvious in retrospect; however, very few of them are actually obvious when you make them."
—David Sze

ANGELS AND VENTURE CAPITALISTS

Angel investors typically write checks between $10,000 to $100,000. VCs (venture capitalists) can write multimillion-dollar checks. Angels are often doctors or lawyers using their own money, while venture capitalists are using other people's money.

If your dream or business or large-scale project require tens of thousands of dollars or even millions or hundreds of millions—then you are looking for angels or venture capitalists. I will explain the difference depending on your needs—and how to find and cultivate them so you have a relationship that helps you fund your ongoing work.

Angel investors typically write checks between $10,000 to $100,000; VCs (venture capitalists) can write multimillion-dollar checks. Angels are often doctors or lawyers using their own money, while venture capitalists are using other people's money. Angels often take a personal interest in a project and may simply believe strongly in the person behind it—that's you! They're usually swayed more by personal concerns than by financial ones.

Venture capitalists are looking for a "Unicorn," which means they are looking for a business start-up that seems to be interesting, but could turn into something giant. Snapchat is a Unicorn, Airbnb is a Unicorn, and these are businesses that can generate millions of dollars, perhaps hundreds of millions of dollars.

ANGELS

First things first: to approach an angel or a VC, you will need a business plan with a budget. This is usually not something you can do on your own. You can find resources online to help you with your business plan or you can ask a local chapter of a small business association to help. The next thing you need is a pitch, otherwise known as the "elevator pitch," which is your presentation in under five minutes of what your idea is and how much money you need. Angel investors are often much more quirky and flexible with what they can offer, unlike a VC. It used to be quite difficult to find out where the angels are, but now there are many networks. Funding Post is one of those networks created by angels and other organizations. ACEnet is another network of small investors and angels that meet online and was developed by SBA, the Small Business Administration. The Angel Capital Association is another network you can research to find angels. It's important to keep in mind that these angels are often funding unconventional ideas, which is quite different from VCs. If you look into some of the resources above, you can find out when angel investors are in your area, and using a tool like Funding Post you can attend an event (have your pitch ready) and meet several in one place, often including VCs as well.

If you are turned down by one or twenty angels, don't give up, because as I said, angels can be quirky, so keep trying and each time you will get feedback and your next pitch will be stronger. Once you find an angel it can be a relationship or a series of relationships that can last for a decade or more and be very rewarding on a personal and professional level.

VENTURE CAPITALISTS

Venture capitalists are another story. They are more conservative, but since they are often working with others, they can pool resources and potentially write checks for millions of dollars. Venture capitalists usually give money over a four-year period, so it is important to know how they work, which means doing research with a local chapter of SBA (Small Business Administration) to learn more and get feedback on your plan.

Also, with venture capital, it is important that your dream is big—very big! They are in it to make money (lots of it) so you should be planning to do the same. However, there are different scales of asking. If you want under one million, you can look for micro-VCs, who have smaller funds to draw from. If you want a larger amount, like $10 million, then you need a VC with a larger fund. That means it is best to know the average size of the check they tend to cut—to know if it is the right VC for you—because the check will typically be cut four times in a four-year period. It is exciting to think this large, so don't hesitate to try out your pitch.

If you are turned down by one or twenty angels, don't give up, because as I said, angels can be quirky, so keep trying and each time you will get feedback and your next pitch will be stronger. Once you find an angel it can be a relationship or a series of relationships that can last for a decade or more and be very rewarding on a personal and professional level.

CHAPTER 9 CHECKLIST

1. Decide on your business goal, then make a budget for your first round of funding.

2. Write down and practice your pitch to an angel or venture capitalist; it should be five minutes or less and exciting, so be enthusiastic and practice in front of a mirror.

3. Seek out specific angel or VC networks and attend a meeting (see details in chapter).

4. Enlist the help of at least one other friend in further developing your business.

5. Try out your pitch on three friends and take notes about their comments and questions.

6. Revise your pitch at least once after step 5.

7. Depending on your direction—angel or VC—ask for the appropriate amount of money, not too much or too little. Research the angels or VCs to find their sweet spot for funding.

8. Get a new set of clothes—conservative business dress, but add a dash of color.

9. Make your first pitch after the above steps.

10. Make five more pitches after the above pitch, because you can expect to do this many times.

11. Assume you make at least twenty pitches before you get real interest.

12. After your first round of funding, plan the next pitch and repeat these steps.

"When we adopt a dog or any pet, we know it is going to end with us having to say good-bye, but we still do it. And we do it for a very good reason: They bring so much joy and optimism and happiness. They attack every moment of every day with that attitude."
—Bruce Cameron

PET PARTIES: LOCAL FUNDRAISER FOR ANY CAUSE

Life can be ever so serious at times. Every day brings new challenges to be overcome, a constant vigilance to keep yourself and your dreams alive. As I have discussed before, raising capital is one of the top priorities and often the biggest obstacle to any artist, entrepreneur, visionary, or anyone who needs to raise money for that matter! Who says you can't combine your need to fundraise with a little levity? Sometimes the wildest ideas are the ones that take off. Let's face it, everybody is looking for a reason to laugh.

Enter the pet party. A sweet and entirely irreverent way to raise a little green and have a great time while you're at it.

These days, pets have achieved familial status. Folks want to pamper their furry friends like never before. There are pet spas, pet bakeries, pet enrichment classes, you name it, somebody is probably doing it. Why not let this work for you?

The first thing you will need to throw your very own pet party is a venue. Outdoor venues are strongly recommended in order to give animals the space they need to be, well, animals. Ask around at your local parks and recreation office or churches to see who might have a green space you can reserve.

This event can be whatever you want to make it. Your imagination is the only limit. Here are a few ideas you might consider. The entry fee for most of these ideas is the main fundraiser.

PET FUN FAIR

Invite guests to a carnival aimed at four-legged friends. Offer pet-friendly treats, obstacle courses, contests for the best pet costume (yes, I said pet costume), or better yet, contests for the best pet and owner costume combination. If you have artist friends who are adept at making quick sketches, have a caricature booth or pet portraiture on-site.

Who says you can't combine your need to fundraise with a little levity? Sometimes the wildest ideas are the ones that take off. Let's face it, everybody is looking for a reason to laugh.

PET WEDDING

This is a tradition among some pet owners. Furry friends don bride and groom costumes and head down the aisle. Host an elegant affair, complete with (fake) flowers and a sumptuous pet buffet. Make sure any food you serve is safe for all animals.

PAINT YOUR PET PARTY

Host an afternoon of artistic endeavor. Invite guests to bring their pet and try their hand at turning Fido into a masterpiece. Provide inexpensive art supplies and paper, and guide your guests through the process of creating their own pet portraits.

DOG WASH

Find a spot where you have access to running water and where it's okay to make a bit of a mess. For a small fee, give dogs a bath and a brushing. Offer various pet spa packages at different price levels. If you're feeling very ambitious, have a dog nail painting station for those who want to go all out.

There are no limits to the possibilities when it comes to throwing your own pet party fundraiser. Be sure to get the word out (some flyers, a Facebook event, word of mouth) and set up a suggested donation at the entrance. Once people are in the gate, make sure they get their money's worth. This doesn't have to cost you an arm and a leg to do either; there are lots of ways to ensure a good time for all on a tight budget. Here are a couple of ideas to keep your crowd happy on the big day.

- Bake your own dog treats to offer attendees. Recipes abound online for all kinds of homemade pet goodies. Brush off your bakeware and get cooking.

- Hold raffles for pet-themed door prizes. They don't have to be anything very fancy. Every guest receives a raffle ticket at the entrance for a chance to win. Have a few prizes. Things like a pack of pet treats, a grooming brush set, or an offer for a free pet portrait.

No matter what you plan, be sure to fully disclose the meaning behind the event. Let your guests know that you are fundraising. Consider donating a portion of any proceeds raised to a local animal shelter. Not only is this a good way to incentivize people to attend your event, it also gives back to the community you're asking for support from.

These days, pets have achieved familial status. Folks want to pamper their furry friends like never before. There are pet spas, pet bakeries, pet enrichment classes, you name it, somebody is probably doing it. Why not let this work for your fundraising efforts?

A pet party is indeed a very silly fundraising idea, and that's the whole point. All too often we get caught up in the seriousness of things. Pets are one of life's best reminders to live every moment. Anyone who has ever watched a dog for any length of time can understand what it looks like to be truly present. What's more, pets radiate joy, something we could all use more of. Reaching out to people's pets is a great way to broaden your network and a fun way to bring the community together.

CHAPTER 10 CHECKLIST

1. Plan a Pet Party and pick a home or public venue for it, ideally an outdoor space so the animals can have fun.

2. Make a fixed entry fee; that is your fundraising tool.

3. Plan a series of fun events. Feel free to make up your own.

4. Have a pet wedding, and a photographer that gives out Polaroids (nothing like instant prints).

5. Have a "best pet costume" contest and give treats for prizes or certificates.

6. Have a painting section where owners learn to paint their pets using finger paint.

7. Have a dog wash area, and for an extra fee, give their dog a shampoo.

8. Develop Pet Spa packages for an extra fee, like painting nails.

9. Make a Facebook page for the party and invite everyone you know that has a dog to come and post pictures of the event there.

10. Send out a press release about the party and the fundraiser to all local media.

11. Take pictures of the whole event and share them regularly on social media, even after the event, to get people wanting another event.

12. Let everyone know (via the dedicated Facebook page and posts) exactly how much you raised with this fun party, to encourage another one.

"When it comes to fundraising for a social enterprise, if you are pursuing your true passion, you'll learn to become great at your craft because you'll care so much about perfecting the skills necessary to make that dream a reality."
—Adam Braun

THE CLASSICS, ABBREVIATED AND READY FOR UPDATING

I have discussed some pretty wacky ideas. From pet parties to merchandise campaigns, we've explored how to put a little planning and elbow grease into conjuring up some funds. But what about the classics? The traditional fundraisers that don't require a lot of unusual effort? I'll give you some ideas for the simplest, most obvious ways of raising some capital that you might not have thought about.

GROUP RUMMAGE SALE

Gather a collection of friends and colleagues and ask them to clear out their closets. Pool together your unwanted (but still in good condition!) items and plan a rummage sale. The great part about this is that you don't need a special venue. You can hold this sale in someone's driveway or garage. While you're at it, mix in a section of original art available for purchase. At the end of the day, divide the proceeds evenly or allow each participant their own table where they can collect their own cash for the items they sell.

BAKE SALE

This old chestnut can easily go hand in hand with your rummage sale or it can stand on its own depending on how much baking you and your collaborators are willing to do. Be organized in your planning so that everyone brings something different to the table—you don't want ten batches of chocolate chip cookies, after all. Play up your baking strengths. Be careful about the time of year. A bake sale near the holidays can be lucrative if you offer up the sort of treats that people want to share at their holiday feasts. If there are perfect pie makers among your ranks, why not bake up a bunch of pies just in time for Thanksgiving? If you have some serious cooking chops and want to take things to the next level, use your social media channels to accept orders for baked treats to be delivered in time for the holidays. A bake sale can be as simple or complex as your abilities allow.

The tricky part about a raffle is coming up with a desirable prize. If you have friends who own local businesses, maybe they could offer a good or service. Of course, a piece of beautiful art is always a wonderful prize.

RAFFLE

The tricky part about a raffle is coming up with a desirable prize. If you have friends who own local businesses, maybe they could offer a good or service. Of course, a piece of beautiful art is always a wonderful prize. When holding a raffle it is important to get the word out. Unlike a rummage sale, a raffle isn't going to be apparent to passersby. Use social media and local outlets to promote your fundraiser. Ask local businesses if you can set up a table outside and sell tickets for an afternoon. Consider your price scheme. Maybe you want to incentivize people to buy more than one ticket by offering bulk discounts—$2 per ticket or five for $8—just a little deal so that folks might be inclined to spend a little more and improve their chances.

CLOTHING DRIVE

This one requires a third party, but it can be a great way to raise funds for your own purposes while also helping out a great organization. Best suited to art collective or nonprofit, a clothing drive is easily organized with the help of GoodThrift who will do most of the work for you! All you do is get the word out and collect as much clothing as you can in your allotted time. Once your clothing drive is through, GoodThrift will pay you per pound of clothing collected.

Plan a pancake breakfast with all the trimmings and get the word out. Sweeten the event with games and door prizes—you could even rent or borrow some character costumes to delight the younger crowd. If you plan near a holiday, consider having the Easter Bunny or Santa Claus make an appearance.

PANCAKE BREAKFAST

This one does require a little more effort and probably a venue, but often a local church with a kitchen will allow organizations to come in and hold events. Pancakes are as easy as can be to make, and very economical, too. Plan a pancake breakfast with all the trimmings and get the word out. Sweeten the event with games and door prizes—you could even rent or borrow some character costumes to delight the younger crowd. If you plan near a holiday, consider having the Easter Bunny or Santa Claus make an appearance. Be sure to advertise this, as it will draw in crowds of parents eager to make special memories for their little ones.

TRIVIA NIGHT

Once again you will need a venue for this, but just like with the pancake breakfast, a church can be a useful resource. You can also consider approaching local bars and pubs to see whether one might like to team up to offer a fun trivia night to their patrons. Decide up front how any profits will be divided. Once you have a basic idea for your event, you'll need to come up with some good questions. Having more than one round will make this event last and give people time to really settle in and challenge their intellect. Common wisdom suggests that five rounds of ten questions each plus a double-or-nothing bonus question in the final round makes for a great trivia night. Don't forget to publicize it as much as possible.

There are so many ways you can raise some money and have fun while you do it. As I've said before, the possibilities are limited only by your own imagination.

AFTERWORD

If your friends, family, or partner aren't behind you 100 percent, don't waste time trying to win them over. Instead, seek out a friend who will support you or start a group of like-minded people to work with on a weekly basis. I can't overestimate the importance of this!

While you tackle one of these ideas, keep in mind that having a support system around you is essential. If your friends, family, or partner aren't behind you 100 percent, don't waste time trying to win them over. Instead, seek out a friend who will support you or start a group of like-minded people to work with on a weekly basis. I can't overestimate the importance of this! A chamber of commerce as well as cooperative work spaces may have the kind of local support you are looking for; if in doubt, try one of those places first. I also teach classes in these topics, and you can learn more about those support groups by writing to me (brainardcarey@gmail.com).

Stay focused on your idea and you will progress along the path to realizing it!

If you have questions, feel free to write to me.

SUGGESTED READING

Here are books
that may help you
with more ideas for
fundraising as well
as philosophical
inspiration, poetry, and
just books I love—and
a few of my own books
as well.

The Art of Persuasion: Winning without Intimidation—Bob Burg

The Art of the Pitch: Persuasion and Presentation Skills That Win Business—Peter Coughter

The Art of Startup Fundraising: Pitching Investors, Negotiating the Deal, and Everything Else Entrepreneurs Need to Know—Alejandro Cremades

The Art World Demystified: How Artists Define and Achieve Their Goals—Brainard Carey

The Ask: How to Ask for Support for Your Nonprofit Cause, Creative Project, or Business Venture—Laura Fredricks

Ask Without Fear! A Simple Guide to Connecting Donors with What Matters to Them Most—Marc A. Pitman

Asking Styles: Harness Your Personal Fundraising Power—Andrea Kihlstedt

Between the World and Me—Ta-Nehisi Coates

Complete Poems, 1904–1962—e. e. cummings

A Course in Miracles—Helen Schucman

The Essential Fundraising Handbook for Small Nonprofits—Betsy Baker, Kirsten Bullock, Gayle L. Gifford, Pamela Grow, Lori L. Jacobwith, Marc A. Pitman, Sandy Rees, and Sherry Truhlar

Hitch-22: A Memoir—Christopher Hitchens

How to Sell Anything to Anybody—Joe Girard

How to Win Friends & Influence People: The Only Book You Need to Lead You to Success—Dale Carnegie

It's NOT JUST about the Money: How to Build Authentic Major Donor Relationships—Richard Perry and Jeff Schreifels

The Little Prince—Antoine de Saint-Exupéry

Major Gift Fundraising for Small Shops: How to Leverage Your Annual Fund in Only Five Hours per Week—Amy Eisenstein

Making Money with Donor Newsletters—Tom Ahern

Meditations—Marcus Aurelius

New Markets for Artists: How to Sell, Fund Projects, and Exhibit Using Social Media, DIY Pop-Ups, eBay, Kickstarter, and Much More—Brainard Carey

The Obstacle Is the Way: The Timeless Art of Turning Trials into Triumph—Ryan Holiday

On the Shortness of Life: Life Is Long if You Know How to Use It—Seneca

the princess saves herself in this one—amanda lovelace

Relationship Fundraising: A Donor-Based Approach to the Business of Raising Money—Ken Burnett

The River of Doubt: Theodore Roosevelt's Darkest Journey—Candice Millard

Stoic Spiritual Exercises—Elen Buzaré

INDEX

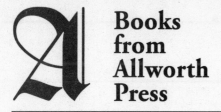

Books from Allworth Press

The Art World Demystified
by Brainard Carey (6 × 9, 308 pages, paperback, $19.99)

The Artist-Gallery Partnership (Revised Edition)
by Tad Crawford and Susan Mellon with foreword by Daniel Grant (6 × 9, 216 pages, paperback, $19.95)

Business and Legal Forms for Fine Artists (Fourth Edition)
by Tad Crawford (8½ × 11, 160 pages, paperback, $24.95)

The Copyright Guide (Fourth Edition)
by Lee Wilson (6 × 9, 304 pages, hardcover, $24.99)

Create Your Art Career
by Rhonda Schaller (6 × 9, 208 pages, paperback, $19.95)

Legal Guide for the Visual Artist (Fifth Edition)
by Tad Crawford (8½ × 11, 304 pages, paperback, $29.95)

Love & Money
by Ann-Margaret Carrozza (6 × 9, 240 pages, paperback, $19.99)

Making It in the Art World
by Brainard Carey (6 × 9, 256 pages, paperback, $19.95)

The Money Mentor
by Tad Crawford (6 × 9, 272 pages, paperback, $24.95)

The Patent Guide (Second Edition)
by Carl Battle and Andrea Small (6 × 9, 356 pages, hardcover, $24.99)

The Profitable Artist (Second Edition)
by New York Foundation for the Arts (6 × 9, 240 pages, paperback, $24.99)

The Secret Life of Money
by Tad Crawford (5½ × 8½, 304 pages, paperback, $19.95)

Selling Art without Galleries (Second Edition)
by Daniel Grant (6 × 9, 256 pages, paperback, $19.99)

Starting Your Career as a Professional Blogger
by Jacqueline Bodnar (6 × 9, 192 pages, paperback, $19.95)

The Trademark Guide (Third Edition)
by Lee Wilson (6 × 9, 272 pages, hardcover, $24.99)

To see our complete catalog or to order online, please visit *www.allworth.com*.